Doll Artist
Show Planner

Contributors
LauNae Books
Lisa Ford Doll Art
Discover Dolls Dollshows

Show Bookings

Record your show bookings and related costs here to keep your accounts accurate.

Date		Hotel Room Booked	
Show Address		Hotel Costs	
		Meals	
		Travel Costs	

Date		Hotel Room Booked	
Show Address		Hotel Costs	
		Meals	
		Travel Costs	

Date		Hotel Room Booked	
Show Address		Hotel Costs	
		Meals	
		Travel Costs	

Date		Hotel Room Booked	
Show Address		Hotel Costs	
		Meals	
		Travel Costs	

Show Bookings

Record your show bookings and related costs here to keep your accounts accurate.

Date		Hotel Room Booked	
Show Address		Hotel Costs	
		Meals	
		Travel Costs	

Date		Hotel Room Booked	
Show Address		Hotel Costs	
		Meals	
		Travel Costs	

Date		Hotel Room Booked	
Show Address		Hotel Costs	
		Meals	
		Travel Costs	

Date		Hotel Room Booked	
Show Address		Hotel Costs	
		Meals	
		Travel Costs	

To Do

Don't put off until tomorrow what you could get done today

Date		Done
		☐
		☐
		☐
		☐
		☐
		☐
		☐
		☐
		☐
		☐
		☐
		☐
		☐
		☐
		☐

To Do

Don't put off until tomorrow what you could get done today

Date		Done
		☐
		☐
		☐
		☐
		☐
		☐
		☐
		☐
		☐
		☐
		☐
		☐
		☐
		☐
		☐

Show Bookings

Record your show bookings and related costs here to keep your accounts accurate.

Date		Hotel Room Booked	
Show Address		Hotel Costs	
		Meals	
		Travel Costs	

Date		Hotel Room Booked	
Show Address		Hotel Costs	
		Meals	
		Travel Costs	

Date		Hotel Room Booked	
Show Address		Hotel Costs	
		Meals	
		Travel Costs	

Date		Hotel Room Booked	
Show Address		Hotel Costs	
		Meals	
		Travel Costs	

Show Bookings

Record your show bookings and related costs here to keep your accounts accurate.

Date		Hotel Room Booked	
Show Address		Hotel Costs	
		Meals	
		Travel Costs	

Date		Hotel Room Booked	
Show Address		Hotel Costs	
		Meals	
		Travel Costs	

Date		Hotel Room Booked	
Show Address		Hotel Costs	
		Meals	
		Travel Costs	

Date		Hotel Room Booked	
Show Address		Hotel Costs	
		Meals	
		Travel Costs	

To Do

Don't put off until tomorrow what you could get done today

Date		Done
		☐
		☐
		☐
		☐
		☐
		☐
		☐
		☐
		☐
		☐
		☐
		☐
		☐
		☐
		☐

To Do

Don't put off until tomorrow what you could get done today

Date		Done
		☐
		☐
		☐
		☐
		☐
		☐
		☐
		☐
		☐
		☐
		☐
		☐
		☐
		☐
		☐

Show Bookings

Record your show bookings and related costs here to keep your accounts accurate.

Date		Hotel Room Booked	
Show Address		Hotel Costs	
		Meals	
		Travel Costs	

Date		Hotel Room Booked	
Show Address		Hotel Costs	
		Meals	
		Travel Costs	

Date		Hotel Room Booked	
Show Address		Hotel Costs	
		Meals	
		Travel Costs	

Date		Hotel Room Booked	
Show Address		Hotel Costs	
		Meals	
		Travel Costs	

Show Bookings

Record your show bookings and related costs here to keep your accounts accurate.

Date		Hotel Room Booked	
Show Address		Hotel Costs	
		Meals	
		Travel Costs	

Date		Hotel Room Booked	
Show Address		Hotel Costs	
		Meals	
		Travel Costs	

Date		Hotel Room Booked	
Show Address		Hotel Costs	
		Meals	
		Travel Costs	

Date		Hotel Room Booked	
Show Address		Hotel Costs	
		Meals	
		Travel Costs	

To Do

Don't put off until tomorrow what you could get done today

Date		Done
		☐
		☐
		☐
		☐
		☐
		☐
		☐
		☐
		☐
		☐
		☐
		☐
		☐
		☐
		☐

To Do

Don't put off until tomorrow what you could get done today

Date		Done
		☐
		☐
		☐
		☐
		☐
		☐
		☐
		☐
		☐
		☐
		☐
		☐
		☐
		☐
		☐

Show Bookings

Record your show bookings and related costs here to keep your accounts accurate.

Date		Hotel Room Booked	
Show Address		Hotel Costs	
		Meals	
		Travel Costs	

Date		Hotel Room Booked	
Show Address		Hotel Costs	
		Meals	
		Travel Costs	

Date		Hotel Room Booked	
Show Address		Hotel Costs	
		Meals	
		Travel Costs	

Date		Hotel Room Booked	
Show Address		Hotel Costs	
		Meals	
		Travel Costs	

Show Bookings

Record your show bookings and related costs here to keep your accounts accurate.

Date		Hotel Room Booked	
Show Address		Hotel Costs	
		Meals	
		Travel Costs	

Date		Hotel Room Booked	
Show Address		Hotel Costs	
		Meals	
		Travel Costs	

Date		Hotel Room Booked	
Show Address		Hotel Costs	
		Meals	
		Travel Costs	

Date		Hotel Room Booked	
Show Address		Hotel Costs	
		Meals	
		Travel Costs	

To Do

Don't put off until tomorrow what you could get done today

Date		Done
		☐
		☐
		☐
		☐
		☐
		☐
		☐
		☐
		☐
		☐
		☐
		☐
		☐
		☐
		☐

To Do

Don't put off until tomorrow what you could get done today

Date		Done
		☐
		☐
		☐
		☐
		☐
		☐
		☐
		☐
		☐
		☐
		☐
		☐
		☐
		☐
		☐

Show Bookings

Record your show bookings and related costs here to keep your accounts accurate.

Date		Hotel Room Booked	
Show Address		Hotel Costs	
		Meals	
		Travel Costs	

Date		Hotel Room Booked	
Show Address		Hotel Costs	
		Meals	
		Travel Costs	

Date		Hotel Room Booked	
Show Address		Hotel Costs	
		Meals	
		Travel Costs	

Date		Hotel Room Booked	
Show Address		Hotel Costs	
		Meals	
		Travel Costs	

Show Bookings

Record your show bookings and related costs here to keep your accounts accurate.

Date		Hotel Room Booked	
Show Address		Hotel Costs	
		Meals	
		Travel Costs	

Date		Hotel Room Booked	
Show Address		Hotel Costs	
		Meals	
		Travel Costs	

Date		Hotel Room Booked	
Show Address		Hotel Costs	
		Meals	
		Travel Costs	

Date		Hotel Room Booked	
Show Address		Hotel Costs	
		Meals	
		Travel Costs	

To Do

Don't put off until tomorrow what you could get done today

Date		Done
		☐
		☐
		☐
		☐
		☐
		☐
		☐
		☐
		☐
		☐
		☐
		☐
		☐
		☐
		☐

To Do

Don't put off until tomorrow what you could get done today

Date		Done
		☐
		☐
		☐
		☐
		☐
		☐
		☐
		☐
		☐
		☐
		☐
		☐
		☐
		☐
		☐

Price List

Price List

Record the wholesale and retail prices of your products this will make doing your accounts easier

Item Description	Qty	W/Sale Price	Retail Price

Price List

Record the wholesale and retail prices of your products this will make doing your accounts easier

Item Description	Qty	W/Sale Price	Retail Price

Price List

Record the wholesale and retail prices of your products this will make doing your accounts easier

Item Description	Qty	W/Sale Price	Retail Price

Price List

Record the wholesale and retail prices of your products this will make doing your accounts easier

Item Description	Qty	W/Sale Price	Retail Price

Price List

Record the wholesale and retail prices of your products this will make doing your accounts easier

Item Description	Qty	W/Sale Price	Retail Price

Price List

Record the wholesale and retail prices of your products this will make doing your accounts easier

Item Description	Qty	W/Sale Price	Retail Price

Price List

Record the wholesale and retail prices of your products this will make doing your accounts easier

Item Description	Qty	W/Sale Price	Retail Price

Price List

Record the wholesale and retail prices of your products this will make doing your accounts easier

Item Description	Qty	W/Sale Price	Retail Price

Price List

Record the wholesale and retail prices of your products this will make doing your accounts easier

Item Description	Qty	W/Sale Price	Retail Price

Price List

Record the wholesale and retail prices of your products this will make doing your accounts easier

Item Description	Qty	W/Sale Price	Retail Price

Price List

Record the wholesale and retail prices of your products this will make doing your accounts easier

Item Description	Qty	W/Sale Price	Retail Price

Price List

Record the wholesale and retail prices of your products this will make doing your accounts easier

Item Description	Qty	W/Sale Price	Retail Price

Doll Show
Sales

Doll Show

Date: _____

Item Description	Qty	Price	Subtotal
		Page Total	

Item Description	Qty	Price	Subtotal
		Page Total	
		Total	

Notes

Purchases

How did today's show go?

Items that need replacing

Improvements to Display

Inspiration

Doll Show

Date: _____

Item Description	Qty	Price	Subtotal
	Page Total		

Item Description	Qty	Price	Subtotal
	Page Total		
	Total		

Notes

Purchases

How did today's show go?

Items that need replacing

Improvements to Display

Inspiration

Doll Show

Date:

Item Description	Qty	Price	Subtotal
		Page Total	

Item Description	Qty	Price	Subtotal
	Page Total		
	Total		

Notes

Purchases

How did today's show go?

Items that need replacing

Improvements to Display

Inspiration

Doll Show _____

Date: _____

Item Description	Qty	Price	Subtotal
	Page Total		

Item Description	Qty	Price	Subtotal
		Page Total	
		Total	

Notes

Purchases

How did today's show go?

Items that need replacing

Improvements to Display

Inspiration

Doll Show

Date:

Item Description	Qty	Price	Subtotal
		Page Total	

Item Description	Qty	Price	Subtotal
		Page Total	
		Total	

Notes

Purchases

How did today's show go?

Items that need replacing

Improvements to Display

Inspiration

Doll Show _____

Date: _____

Item Description	Qty	Price	Subtotal
		Page Total	

Item Description	Qty	Price	Subtotal
	Page Total		
	Total		

Notes

Purchases

How did today's show go?

Items that need replacing

Improvements to Display

Inspiration

Doll Show _____

Date: _____

Item Description	Qty	Price	Subtotal
	Page Total		

Item Description	Qty	Price	Subtotal
	Page Total		
	Total		

Notes

Purchases

How did today's show go?

Items that need replacing

Improvements to Display

Inspiration

Doll Show

Date:

Item Description	Qty	Price	Subtotal
	Page Total		

Item Description	Qty	Price	Subtotal
	Page Total		
	Total		

Notes

Purchases

How did today's show go?

Items that need replacing

Improvements to Display

Inspiration

Doll Show _____

Date: _____

Item Description	Qty	Price	Subtotal
		Page Total	

Item Description	Qty	Price	Subtotal
	Page Total		
	Total		

Notes

Purchases

How did today's show go?

Items that need replacing

Improvements to Display

Inspiration

Doll Show _____

Date: _____

Item Description	Qty	Price	Subtotal
		Page Total	

Item Description	Qty	Price	Subtotal
	Page Total		
	Total		

Notes

Purchases

How did today's show go?

Items that need replacing

Improvements to Display

Inspiration

Doll Show _____

Date: _____

Item Description	Qty	Price	Subtotal
		Page Total	

Item Description	Qty	Price	Subtotal
		Page Total	
		Total	

Notes

Purchases

How did today's show go?

Items that need replacing

Improvements to Display

Inspiration

Doll Show

Date:

Item Description	Qty	Price	Subtotal
	Page Total		

Item Description	Qty	Price	Subtotal
		Page Total	
		Total	

Notes

Purchases

How did today's show go?

Items that need replacing

Improvements to Display

Inspiration

Doll Show _____

Date: _____

Item Description	Qty	Price	Subtotal
		Page Total	

Item Description	Qty	Price	Subtotal
	Page Total		
	Total		

Notes

Purchases

How did today's show go?

Items that need replacing

Improvements to Display

Inspiration

Doll Show _____

Date: _____

Item Description	Qty	Price	Subtotal
	Page Total		

Item Description	Qty	Price	Subtotal
	Page Total		
	Total		

Notes

Purchases

How did today's show go?

Items that need replacing

Improvements to Display

Inspiration

Doll Show _____

Date: _____

Item Description	Qty	Price	Subtotal
		Page Total	

Item Description	Qty	Price	Subtotal
	Page Total		
	Total		

Notes

Purchases

How did today's show go?

Items that need replacing

Improvements to Display

Inspiration

Doll Show

Date: _____

Item Description	Qty	Price	Subtotal
		Page Total	

Item Description	Qty	Price	Subtotal
		Page Total	
		Total	

Notes

Purchases

How did today's show go?

Items that need replacing

Improvements to Display

Inspiration

Doll Show

Date: _____

Item Description	Qty	Price	Subtotal
	Page Total		

Item Description	Qty	Price	Subtotal
		Page Total	
		Total	

Notes

Purchases

How did today's show go?

Items that need replacing

Improvements to Display

Inspiration

Doll Show _____

Date: _____

Item Description	Qty	Price	Subtotal
		Page Total	

Item Description	Qty	Price	Subtotal
	Page Total		
	Total		

Notes

Purchases

How did today's show go?

Items that need replacing

Improvements to Display

Inspiration

Doll Show

Date:

Item Description	Qty	Price	Subtotal
		Page Total	

Item Description	Qty	Price	Subtotal
		Page Total	
		Total	

Notes

Purchases

How did today's show go?

Items that need replacing

Improvements to Display

Inspiration

Doll Show

Date:

Item Description	Qty	Price	Subtotal
	Page Total		

Item Description	Qty	Price	Subtotal
		Page Total	
		Total	

Notes

Purchases

How did today's show go?

Items that need replacing

Improvements to Display

Inspiration

Doll Show

Date: _____

Item Description	Qty	Price	Subtotal
		Page Total	

Item Description	Qty	Price	Subtotal
		Page Total	
		Total	

Notes

Purchases

How did today's show go?

Items that need replacing

Improvements to Display

Inspiration

Doll Show

Date:

Item Description	Qty	Price	Subtotal
		Page Total	

Item Description	Qty	Price	Subtotal
	Page Total		
	Total		

Notes

Purchases

How did today's show go?

Items that need replacing

Improvements to Display

Inspiration

Doll Sales Record

Doll Name	
Kit Name:	
Sculptor:	
Length	
Weight	
Information	

Rehomed By	
Email:	
Inspected on Collection	Signature: _____ Print Name: _____
Date:	

Doll Name	
Kit Name:	
Sculptor:	
Length	
Weight	

Information	

Rehomed By	
Email:	
Inspected on Collection	Signature: _____ Print Name: _____
Date:	

Doll Name	
Kit Name:	
Sculptor:	
Length	
Weight	

Information

Rehomed By	
Email:	
Inspected on Collection	Signature: _____ Print Name: _____
Date:	

Doll Name	
Kit Name:	
Sculptor:	
Length	
Weight	

Information	

Rehomed By	
Email:	
Inspected on Collection	Signature: _____ Print Name: _____
Date:	

Doll Name	
Kit Name:	
Sculptor:	
Length	
Weight	
Information	

Rehomed By	
Email:	
Inspected on Collection	Signature: _____ Print Name: _____
Date:	

Doll Name	
Kit Name:	
Sculptor:	
Length	
Weight	

Information

Rehomed By	
Email:	
Inspected on Collection	Signature: _____ Print Name: _____
Date:	

Doll Name	
Kit Name:	
Sculptor:	
Length	
Weight	
Information	

Rehomed By	
Email:	
Inspected on Collection	Signature: _____ Print Name: _____
Date:	

Doll Name	
Kit Name:	
Sculptor:	
Length	
Weight	

Information

Rehomed By	
Email:	
Inspected on Collection	Signature: _____ Print Name: _____
Date:	

Doll Name	
Kit Name:	
Sculptor:	
Length	
Weight	

Information

Rehomed By	
Email:	
Inspected on Collection	Signature: ——————————— Print Name: ———————————
Date:	

Doll Name	
Kit Name:	
Sculptor:	
Length	
Weight	

Information	

Rehomed By	
Email:	
Inspected on Collection	Signature: _____ Print Name: _____
Date:	

Doll Name	
Kit Name:	
Sculptor:	
Length	
Weight	
Information	

Rehomed By	
Email:	
Inspected on Collection	Signature: ——————————— Print Name: ———————————
Date:	

Doll Name	
Kit Name:	
Sculptor:	
Length	
Weight	

Information

Rehomed By	
Email:	
Inspected on Collection	Signature: _____ Print Name: _____
Date:	

Doll Name	
Kit Name:	
Sculptor:	
Length	
Weight	

Information

Rehomed By	
Email:	
Inspected on Collection	Signature: _____ Print Name: _____
Date:	

Doll Name	
Kit Name:	
Sculptor:	
Length	
Weight	
Information	

Rehomed By	
Email:	
Inspected on Collection	Signature: _____ Print Name: _____
Date:	

Doll Name	
Kit Name:	
Sculptor:	
Length	
Weight	
Information	

Rehomed By	
Email:	
Inspected on Collection	Signature: _____ Print Name: _____
Date:	

Doll Name	
Kit Name:	
Sculptor:	
Length	
Weight	

Information	

Rehomed By	
Email:	
Inspected on Collection	Signature: _____ Print Name: _____
Date:	

Doll Name	
Kit Name:	
Sculptor:	
Length	
Weight	

Information

Rehomed By	
Email:	
Inspected on Collection	Signature: _____ Print Name: _____
Date:	

Doll Name	
Kit Name:	
Sculptor:	
Length	
Weight	

Information	

Rehomed By	
Email:	
Inspected on Collection	Signature: _____ Print Name: _____
Date:	

Photo

Doll Name	
Kit Name:	
Sculptor:	
Length	
Weight	

Information

Rehomed By	
Email:	
Inspected on Collection	Signature: _____ Print Name: _____
Date:	

Doll Name	
Kit Name:	
Sculptor:	
Length	
Weight	
Information	

Rehomed By	
Email:	
Inspected on Collection	Signature: _____ Print Name: _____
Date:	

Doll Name	
Kit Name:	
Sculptor:	
Length	
Weight	

Information

Rehomed By	
Email:	
Inspected on Collection	Signature: _____ Print Name: _____
Date:	

Photo

Doll Name	
Kit Name:	
Sculptor:	
Length	
Weight	

Information

Rehomed By	
Email:	
Inspected on Collection	Signature: Print Name:
Date:	

Photo

Doll Name	
Kit Name:	
Sculptor:	
Length	
Weight	

Information

Rehomed By	
Email:	
Inspected on Collection	Signature: _____ Print Name: _____
Date:	

Doll Name	
Kit Name:	
Sculptor:	
Length	
Weight	

Information

Rehomed By	
Email:	
Inspected on Collection	Signature: _____ Print Name: _____
Date:	

Photo

Doll Name	
Kit Name:	
Sculptor:	
Length	
Weight	
Information	

Rehomed By	
Email:	
Inspected on Collection	Signature: _____ Print Name: _____
Date:	

Kit List
In Stock

Kit	
Sculptor	
Body Type	

Length		Eyes	
Price		VAT	

Kit	
Sculptor	
Body Type	

Length		Eyes	
Price		VAT	

Kit	
Sculptor	
Body Type	

Length		Eyes	
Price		VAT	

Kit	
Sculptor	
Body Type	

Length		Eyes	
Price		VAT	

Kit	
Sculptor	
Body Type	

Length		Eyes	
Price		VAT	

Kit	
Sculptor	
Body Type	

Length		Eyes	
Price		VAT	

Kit			
Sculptor			
Body Type			
Length		Eyes	
Price		VAT	

Kit			
Sculptor			
Body Type			
Length		Eyes	
Price		VAT	

Kit			
Sculptor			
Body Type			
Length		Eyes	
Price		VAT	

Kit			
Sculptor			
Body Type			
Length		Eyes	
Price		VAT	

Kit			
Sculptor			
Body Type			
Length		Eyes	
Price		VAT	

Kit			
Sculptor			
Body Type			
Length		Eyes	
Price		VAT	

Kit	
Sculptor	
Body Type	

Length		Eyes	
Price		VAT	

Kit	
Sculptor	
Body Type	

Length		Eyes	
Price		VAT	

Kit	
Sculptor	
Body Type	

Length		Eyes	
Price		VAT	

Kit			
Sculptor			
Body Type			
Length		Eyes	
Price		VAT	

Kit			
Sculptor			
Body Type			
Length		Eyes	
Price		VAT	

Kit			
Sculptor			
Body Type			
Length		Eyes	
Price		VAT	

Kit	
Sculptor	
Body Type	

Length		Eyes	
Price		VAT	

Kit	
Sculptor	
Body Type	

Length		Eyes	
Price		VAT	

Kit	
Sculptor	
Body Type	

Length		Eyes	
Price		VAT	

Kit			
Sculptor			
Body Type			
Length		Eyes	
Price		VAT	

Kit			
Sculptor			
Body Type			
Length		Eyes	
Price		VAT	

Kit			
Sculptor			
Body Type			
Length		Eyes	
Price		VAT	

Kit			
Sculptor			
Body Type			
Length		Eyes	
Price		VAT	

Kit			
Sculptor			
Body Type			
Length		Eyes	
Price		VAT	

Kit			
Sculptor			
Body Type			
Length		Eyes	
Price		VAT	

Kit	
Sculptor	
Body Type	

Length		Eyes	
Price		VAT	

Kit	
Sculptor	
Body Type	

Length		Eyes	
Price		VAT	

Kit	
Sculptor	
Body Type	

Length		Eyes	
Price		VAT	

Wish List

Kit	
Sculptor	
Body Type	

Length		Eyes	
Price		Release Date	

Kit	
Sculptor	
Body Type	

Length		Eyes	
Price		Release Date	

Kit	
Sculptor	
Body Type	

Length		Eyes	
Price		Release Date	

Kit	
Sculptor	
Body Type	

Length		Eyes	
Price		Release Date	

Kit	
Sculptor	
Body Type	

Length		Eyes	
Price		Release Date	

Kit	
Sculptor	
Body Type	

Length		Eyes	
Price		Release Date	

Kit	
Sculptor	
Body Type	

Length		Eyes	
Price		Release Date	

Kit	
Sculptor	
Body Type	

Length		Eyes	
Price		Release Date	

Kit	
Sculptor	
Body Type	

Length		Eyes	
Price		Release Date	

Kit	
Sculptor	
Body Type	

Length		Eyes	
Price		Release Date	

Kit	
Sculptor	
Body Type	

Length		Eyes	
Price		Release Date	

Kit	
Sculptor	
Body Type	

Length		Eyes	
Price		Release Date	

Kit			
Sculptor			
Body Type			
Length		Eyes	
Price		Release Date	

Kit			
Sculptor			
Body Type			
Length		Eyes	
Price		Release Date	

Kit			
Sculptor			
Body Type			
Length		Eyes	
Price		Release Date	

Kit	
Sculptor	
Body Type	

Length		Eyes	
Price		Release Date	

Kit	
Sculptor	
Body Type	

Length		Eyes	
Price		Release Date	

Kit	
Sculptor	
Body Type	

Length		Eyes	
Price		Release Date	

Kit	
Sculptor	
Body Type	

Length		Eyes	
Price		Release Date	

Kit	
Sculptor	
Body Type	

Length		Eyes	
Price		Release Date	

Kit	
Sculptor	
Body Type	

Length		Eyes	
Price		Release Date	